Cultural تواصل
Connectives الثقافات

Cultural تواصل
Connectives الثقافات

Rana Abou Rjeily ❁ Mark Batty Publisher ❁ 2011

Cultural Connectives
© 2011 by Rana Abou Rjeily
All Cultural Connectives © its respective creators

BOOK DESIGNER
Rana Abou Rjeily

EDITOR
Buzz Poole

CONTRIBUTING EDITOR
Mouran N Boutros

ARABIC EDITOR
Khalil Abou Rjeily

DESIGN ASSISTANT
Charbel Jamous

TRANSLATOR
Luna Andraos

PRODUCTION MANAGER
Christopher D Salyers

TYPEFACE
RA_Mirsaal Arabic & Latin, designed by Rana Abou Rjeily

SPECIAL THANKS TO
Cecil Hourani, Joe Hatem, Mourad Boutros, and Thomas Milo.

Library of Congress Control #2010931570

Printed and bound in China through Asia Pacific Offset

10 9 8 7 6 5 4 3 2 1 First Edition

All rights reserved
This edition © 2011
Mark Batty Publisher
36 West 37th Street, Suite 409
New York, NY 10018

ISBN: 978-1-9356131-3-8

Distributed outside North America by
Thames & Hudson Ltd
181A High Holborn
London WC1V 7QX
United Kingdom
Tel: 00 44 20 7845 5000
Fax: 00 44 20 7845 5055
www.thameshudson.co.uk

"We shall never understand one another until we reduce the language to seven words.**"**

Gibran Khalil Gibran

for Samira and Khalil إلى سميرة وخليل

Content المحتويات

Preface تمهيد

Since the beginning of the last century several attempts have been made to adapt the calligraphic styles of the Arabic alphabet to the printing press by reducing the number of the many variations of letters and diacritical marks, which made the printers' work slow and expensive. Among these attempts two stand out in terms of quality and authenticity: Nasri Khattar's Unified Arabic typefaces and Mourad and Arlette Boutros's Basic Arabic. Both typefaces represent a typographical compromise between connecting and separate printed letters, while also serving as educational tools to simplify and accelerate the process of learning to read and write Arabic.

A mini-conference to explore the possibility of organizing an experiment to compare the advantages or disadvantages of teaching Basic Arabic instead of traditional methods was held in London and attended by a number of educational experts, including Dr Julinda Abou Nasr, Dr Victor Billeh, Antoine Abi Raad, Leila Tannous, the late Habib Bourguiba Jr, Cecil Hourani, and Mourad Boutros.

When Rana Abou Rjeily worked with us while studying typography and graphic design in London she showed interest in Basic Arabic and decided to include the concept in her thesis. Although initially she claimed that it was possible to produce a typeface in one day (a common fallacy of those who believe the computer can do miracles) she soon realized that much hard work and time is necessary to produce an acceptable and attractive typeface or book.

Cultural Connectives is an interesting and innovative book in its attempt to bring closer together the typographic styles of the Arabic and Latin alphabets. It also asks whether it is possible to replace the present domination of Western culture by a greater openness to Eastern values and traditions, with special reference to design in all its dimensions, including typography. To 'orientalize the West' is an ambitious and daunting challenge; hopefully Rana's book will encourage others to pursue the same exploration.

Cecil Hourani & Mourad Boutros

Understanding Arabic made easy

تسهيل فهم اللغة العربية

How to use this book

Arabic is reputed to be one of the hardest languages to learn. Cultural Connectives will help you understand the basic characteristics of the Arabic script and alphabet by comparing it with the Latin alphabet.

This should be a fun and easy guide to the subject. Each page or spread contains self contained information, which means the book can be read starting at any page.

Cultural Connectives is neither purely academic nor a teaching method – instead it is a reference for anyone interested in the subject. Whether you work in advertising, study type design, or are trying to understand Arabic and avoid common mistakes, this book is for you.

A major obstacle in learning and mastering Arabic is its calligraphic origins and its modern cursive script. You will find the difficulties in learning cursive Arabic disappear by adopting the detached Arabic alphabet used in this book.

With the concept of detached Arabic, each letter has only one form when adapted into type, with only a few exceptions. The new letterforms created are easily recognizable compared with the existing cursive letters.

As a result, this book should help you understand the existing form of the Arabic alphabet and promotes a core concept that other scholars worked on long before this book was published.

Introduction مقدمة

My background

I was born in Lebanon – a small Levantine country situated at the crossroads of Western and Eastern civilizations. Since I was a child I found French and English much easier to learn than Arabic, my first language. Raised in a bilingual community, I learned the Arabic and Latin alphabets without considering their different backgrounds. As I matured, I wanted to know why it was easier to study French and English.

During my typographic design studies I fell in love with Arabic's charming letterforms. After completing my BA in Graphic Design at Notre Dame University in Lebanon, I wanted to learn more and expose myself to new design approaches and typographic solutions. I decided to enroll in the MA Communication Design program at Central Saint Martins College of Art and Design in London – a move that proved to be challenging and inspiring.

Being such a cosmopolitan and vibrant city, London was the ideal creative atmosphere for my studies. As the only Arabic–speaking student in the course, I found myself constantly challenging stereotypes about Middle Eastern culture. Explaining the nuances of written Arabic to Westerners proved to be difficult; my classmates were absolutely fascinated by the script but struggled to give me constructive feedback on my Arabic type design projects.

After considerable research and deliberation, I concluded that the biggest impediment to reading Arabic was its cursive writing style. Arabic is especially difficult because the shape of letters changes based on their location within a word. I knew then that my greatest challenge would be to make written Arabic accessible for those who did not speak Arabic as a first language.

Arabic made easy

Arabic exists in many different forms: classical Arabic (which is used in the Holy Qur'an), colloquial or spoken Arabic (which is different from country to country and region to region), and modern standard Arabic (which is used in media and literature in all Arabic-speaking countries). Arabic typography is based on calligraphy and maintains its traditional origin: it was kept connected when transferred into moveable type while the Latin alphabet was gradually detached during the Renaissance.

I decided to create an easy to read Arabic font by using a detached form of Arabic typography. Calligraphy and typography have very different purposes and, in my opinion, separating Arabic type from calligraphy is not disrespectful – on the contrary, it assists in the development of the language and leaves room for experimentation.

The first part of my project was creating an easy to learn typeface in which the letterforms would be less daunting to read than the regular Arabic typefaces by developing a visual equivalent to Latin typography.

Looking into previous scholarly experimental research and suggestions for making Arabic script easier to learn, I paid close attention to the proposition made in 1947 to the Academy of the Arabic Language in Cairo by the Lebanese architect and typographer Nasri Khattar. Khattar invented a print Arabic form, which was heavily inspired by Latin typography, called Unified Arabic. This version of the Arabic alphabet was detached and had thirty-two characters. Unified Arabic was meant to ease the learning and writing of the script by reducing the number of shapes letters could assume.

Unified Arabic was later developed and reshaped in the 1990s into Basic Arabic by the London-based typographers and calligraphers, Mourad and Arlette Boutros as a commission for Cecil Hourani.

Basic Arabic was designed as a compromise between Khattar's radical proposal to abandon cursive Arabic script and the idea of designing a typographic script with only one shape per letter that would not be joined together when printed. Basic Arabic was simplified but maintained the calligraphic spirit of Arabic cursive scripts.

Basic Arabic unified the forms of Arabic letters, maintained its calligraphic origins, and introduced print writing by separating the letters. Accordingly, it enabled readers to get familiar with single-shape letters.

Basic Arabic was not intended to be a final solution to the problems of printing Arabic, but another step along the way to the ultimate goal of Khattar's Unified Arabic. Basic Arabic was also envisaged as an educational tool to simplify the processes of learning to read and write Arabic. The Unified Arabic and the Basic Arabic projects fascinated me so much that I decided to create my own design of another Basic Arabic typeface with reference to the original Basic Arabic font.

Basic Arabic letters are unconnected and only have one shape per letter, with a few exceptions. The shape of each letter is a combination of all the shapes a traditional letter displays when positioned differently in a word so that the reader will recognize it wherever it stands. Non-Arabic readers will still be able to refer to the traditional shapes and recognize them. I asked Mourad Boutros to assist me in developing my own Arabic typeface and, incredibly, he agreed. The Arabic typeface used throughout this book is my own creation: Mirsaal.

In order to complete this book, designing a Latin version of Mirsaal was a must. Mirsaal Latin holds the same visual characteristics as Mirsaal Arabic: same ascenders and descenders, stroke variation, open counters. Both fonts were developed together, which helps maintain visual balance when used together on the same page.

The second part of the project focused on finding subtle but major differences between the two scripts and explaining them visually. Arabic rules of writing and pronunciation were subsequently applied to the Latin alphabet. The reader will understand the difficulties of traditional Arabic by being able to compare it to the one-shape-per-letter typeface and the Basic Arabic principle.

It should be noted that Cultural Connectives is written using English in comparison with Arabic script as used in Arabic-speaking countries, and not as found in Persian or Urdu, where Arabic script is used to write a different language (although most of the rules still apply).

To ensure the flexibility and survival of Arabic in this digital age, it seems prudent to adapt written Arabic to the contemporary world by detaching it from calligraphy, which is in itself a beautiful art, sure to last through Islamic culture alone. Personally speaking, it would be sad to see nations abandoning their traditional letter-scripts or writing systems for more 'efficient' ones. Isn't that what took place in Turkey? And, indeed, in many other countries throughout history? Wasn't that about to happen in China when Mao Tse Tung suggested replacing Chinese Kanji with the Latin alphabet because the Chinese writing system forms a communication barrier between China and the Western world?

Cultural Connectives is about bridging the gap between the Arabic and Latin alphabets. This new approach of 'Easternizing' the West is one more attempt in the far-reaching and important movement to dissolve cultural barriers and replace them with cultural understanding and mutual respect. I hope this book proves to be a guide to quickly explain the basic principles of Arabic and a useful tool for designers and typographers.

Rana Abou Rjeily

Arabic is the second

الأبجدية العربية هي

most widely used

ثاني أكثر الأبجديات

alphabet in the world.

المستخدمة في العالم.

*Many countries represented in this map use Latin alphabets as a second language such as French and English besides their local scripts.

Arabic alphabet world distribution
Latin alphabet world distribution

إنتشار الأبجدية العربية في العالم

إنتشار الأبجدية اللاتينية في العالم

Arabic is one of the most widely used alphabets in the world. It flourished with the creation of the Holy Qur'an and the spread of Islam. Since Islam prohibits figurative representations (sacred drawings), script is the only representational medium. For this reason, Arabic calligraphy developed in many creative ways over time as it spread across the world due to numerous holy wars and proselytizing. In non-Arabic-speaking countries that converted to Islam, such as Iran, the Arabic alphabet was adopted by adding letters for missing phonemes.

Words in Arabic are written in horizontal Lines from right to Left

Arabic is a Semitic language that has common roots with the Hebrew, Aramaic, Phoenician (Canaanite), and Nabatean languages. All the Semitic family of languages reads from right to left.

Old Greek was written in both directions, from right to left and from left to right in alternate lines. This writing principle was called 'boustrophedon,' meaning "as an ox turns in plowing." With time, writing from left to right dominated and became standard in all Western scripts.

Numerals are written in horizontal lines left to right from

Surprisingly, numerals used when writing in Arabic are Indic numerals and read in the opposite direction of the Arabic script. Some Arabic-speaking countries, as well as most Western countries, use the Arabic numerals 1, 2, 3, 4, 5, 6, 7, 8, 9, and 0.

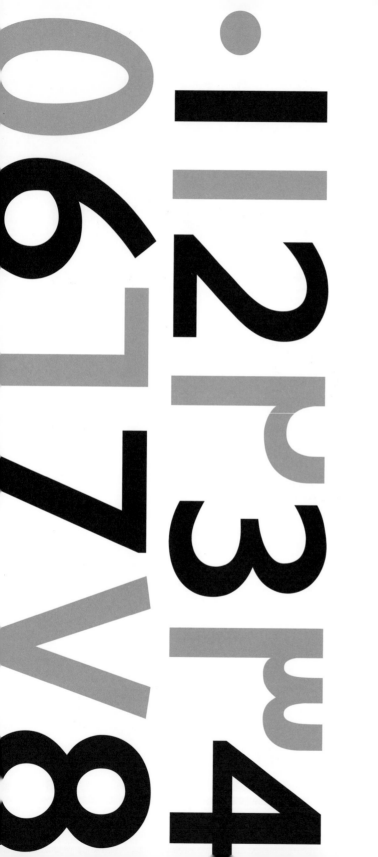

0·II2Ӷ3Ӷ4Ɛ50677V8Λ9٩

Arabs adopted their numerals from India. The term Hindu-Arabic numerals is a misnomer, a proper term for the numerical system used by most Arabs is Arabic-Indic numerals. The Arabic-Indic numerals are still in use in many Arabic-speaking countries. The Indian numerals brought by Arabs to the West during the Islamic conquest of the Iberian Peninsula developed into the Arabic numerals we all know.

joined joined j

d joined

oinedjo

joinedj

**Letters that can be joined are always joined
in both handwritten and printed Arabic.**

Latin-based alphabets have at least two forms: cursive and
print. Typographers in the West gradually disassociated
Latin type from calligraphy while Arabic script maintained
its intrinsic calligraphic nature. Most Arabic letters can be
connected from both of their sides except seven of them
(ä, و, j, ر, د, ذ, ا). These letters can only be connected from
the right side.

Most letters in Arabic change shape according to where they appear in a word. Here is the letter (hā') in four different positions: **isolated...**

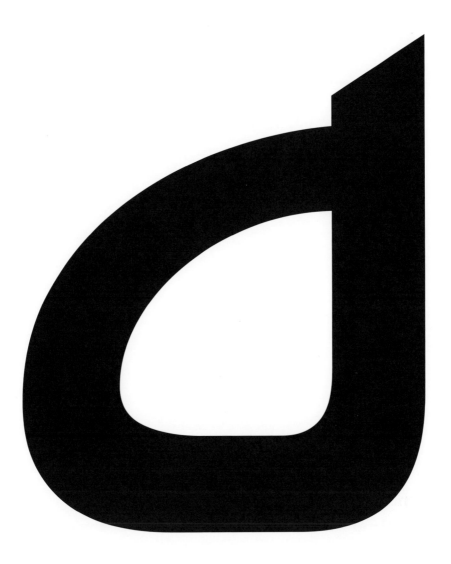

at the end of a word...

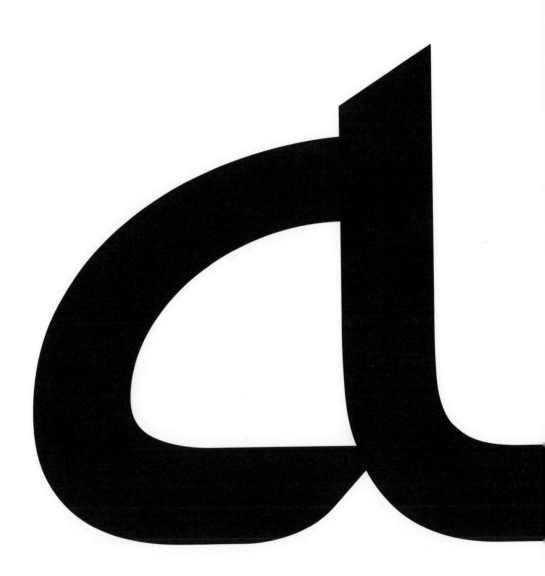

in the middle of a word...

at the beginning of a word...

These are all the same letter. In Mirsaal, this letter has one shape.

letters that connect from the right side

Mirsaal	medial joined / final joined	isolated / medial unjoined / final unjoined
ا	ا	ا
ﺪ	ﺪ	د
ﺬ	ﺬ	ذ
ﺮ	ﺮ	ر
ﺰ	ﺰ	ز
ﻮ	ﻮ	و

letters that connect from both sides

Mirsaal	final form	medial form	initial form	isolated
ﺐ	ﺐ	ﺒ	ﺑ	ب
ﺖ	ﺖ	ﺘ	ﺗ	ت
ﺚ	ﺚ	ﺜ	ﺛ	ث
ﺞ	ﺞ	ﺠ	ﺟ	ج
ﺢ	ﺢ	ﺤ	ﺣ	ح
ﺦ	ﺦ	ﺨ	ﺧ	خ
ﺲ	ﺲ	ﺴ	ﺳ	س
ﺶ	ﺶ	ﺸ	ﺷ	ش
ﺺ	ﺺ	ﺼ	ﺻ	ص
ﺾ	ﺾ	ﻀ	ﺿ	ض
ﻂ	ﻂ	ﻄ	ﻃ	ط

letters that connect from both sides

Mirsaal	final form	medial form	initial form	isolated
ظ	ظ	ظ	ظ	ظ
ع	ع	ع	ع	ع
غ	غ	غ	غ	غ
ف	ف	ف	ف	ف
ق	ق	ق	ق	ق
ك	ك	ك	ك	ك
ل	ل	ل	ل	ل
م	م	م	م	م
ن	ن	ن	ن	ن
ه	ه	ه	ه	ه
ي	ي	ي	ي	ي

Unlike the Latin alphabet, Arabic is only written connected. Of course, some Latin fonts can imitate handwriting by being cursive but these fonts are mostly used for display purposes. Arabic letters change shape according to their position in a word. The four positions are isolated, initial, medial, and final. The typeface Mirsaal solves this issue by having a one-shape-per-letter form, making it easier to learn and memorize the shape of Arabic letters.

variations of other letters

ى	ى	-----	-----	ى
ة	ة	-----	-----	ة

The 'alif maqsūra' (ى) is another form of the letter 'yeh' (ي) used only at the end of a word. It is similar to the final 'yeh' but with no dots under it. The letter 'teh marbouta' (ة) is a variation of the letter 'hā' (ه) with the addition of two dots on top. This letter denotes feminine endings of nouns and adjectives.

e + t =

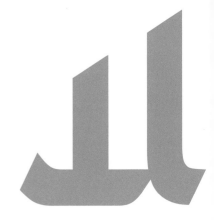

Since Arabic is a cursive script, letters often merge and change shape. A common example would be the 'lam alif'; both the 'lam' and the 'alif' are knotted together to form a vertical two-letter 'la.' With the one-shape-per-letter Arabic typeface this kind of ligature is avoided. This decreases the number of characters to learn.

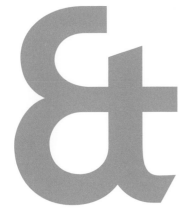

The closest equivalent in Latin typography to the 'lam alif' would be the ampersand (&) meaning 'and,' which originates from the Latin 'et' meaning the same.

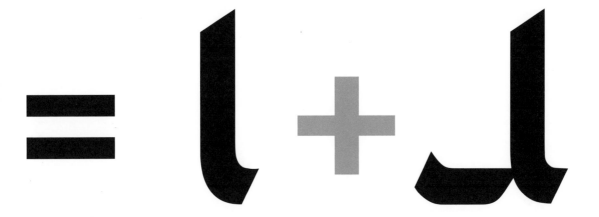

this
is
not
a
zero!

It is number 5 written in Arabic-Indic numerals

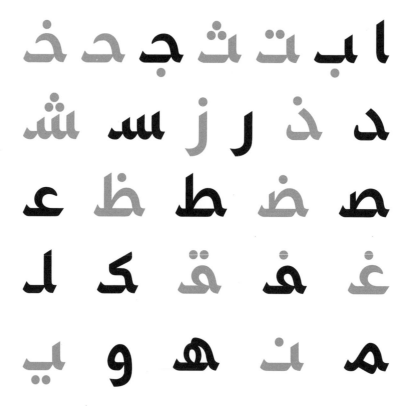

Old Arabic was written with no diacritical marks. They were added around the ninth century in an official reform of Arabic script to avoid confusion and determine the pronunciation of letters that share the same basic shape. Other languages that adopted Arabic script, like Persian, have added diacritical marks to existing letters to create additional sounds that do not exist in the Arabic language.

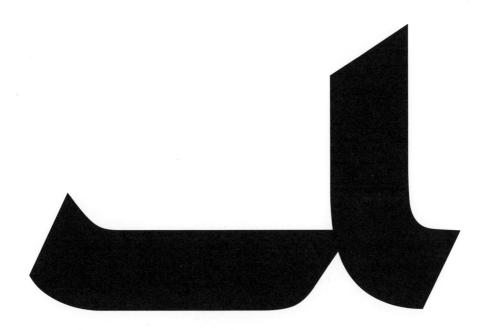

The Arabic alphabet contains 28 letters but only 18 distinct basic shapes in their isolated forms. With Mirsaal Arabic the basic shapes are down to 15.

One distinct shape could be altered with the addition of one, two, or three dots.

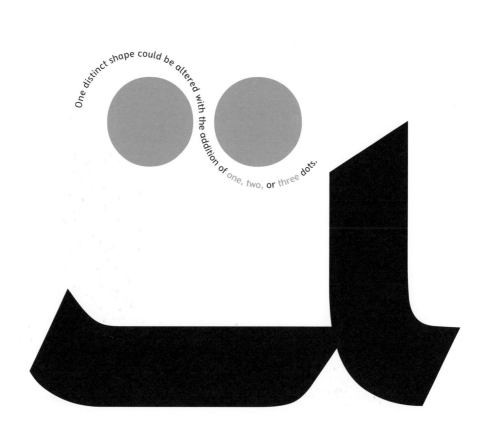

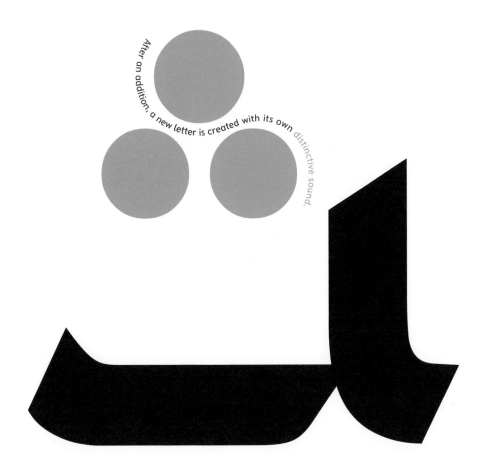

After an addition, a new letter is created with its own distinctive sound.

Cn y rd ths?

Since the Arabic alphabet only contains consonants, short vowels are added in the form of diacritical marks on top of or below the letters in order to clarify pronunciation. The vocalization marks 'fatha,' 'damma,' and 'kasra' became more common when transcribing the Holy Qur'an in order to avoid ambiguity and misinterpretation. Arabic could also be written without diacritical marks.

Words written with no diacritical marks can be read in different ways, for example k–t–b could be read 'kataba' (he wrote) or 'kutiba' (it was written). In such cases pronunciation could be deduced from the context. The 'sukoun' (°) is a diacritical mark shaped like a small circle and placed on top of letters to indicate the absence of a short vowel.

n rbc th thr lng vwls r ncldd n

wrttn wrds bt th thr shrt vwls r

nrmll mttd lthgh th cn b ndctd

b mrks plcd bv nd blw lttrs.

─ The 'fatha': short vowel /a/ ⁞ دَ (da as in dad)

و The 'damma': short vowel /u/ ⁞ دُ (du as in dude)

The 'kasra': short vowel /e/ ⁞ دِ (de as in deduct)
─

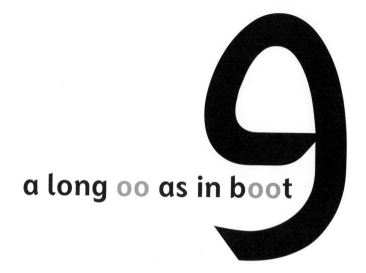

a long oo as in boot

a long aa as in man

a long ee as in beet

*These Arabic letters can be long vowels or consonants.

morgan......morǵ

nelson......nelś

kevin......kev

The nunation (the doubling of short vowels) in Arabic is an addition to a word to indicate the indefinite article /n/ attached to the following vowel:

......**The tanwin 'fatha'**: short vowel /a/+n كلمةً

......**The tanwin 'damma'**: short vowel /u/+n كلمةٌ

......**The tanwin 'kasra'**: short vowel /i/+n كلمةٍ

arrested	arْrested
attendance	atْtendance
essential	esْsential
illustration	ilْlustration
immediate	imْmediate
offensive	ofْfensive

The 'shadda' (ّ) is the miniature shape taken from the letter sīn س (pronounced 'seen') in its stand-alone position by removing its curled tail. It is employed as a stress mark that indicates the doubling of a consonant.

The 'shadda' should always be positioned on top of a letter and can be paired with 'kasra,' 'damma,' or 'fatha' simultaneously on the same letter.

*The examples above represent approximate phonetic equivalents to the shadda.

The 'hamza' (ء) is a glottal stop and a consonant mark placed on a carrier letter (the seat) in one of the three long vowels: 'alif', 'waw,' 'yeh.' The 'hamza' could also be shaped larger at the end of a word or stand alone on the baseline. In this case it is considered a consonant.

The 'madda' is another symbol that could be positioned above the 'alif' (آ). The 'madda' is used to denote an extended "a" sound, in other words, it is used to substitute two 'alif' standing together. 'Wasla' (ٱ) is a symbol positioned above the 'alif' that possesses no phonetic value.

ضظغ ثخذ قرشت سعفص

1000	900	800	700	600	500	400	300	200	100	90	80	70	60

طظ عغ فق ك ل م ت م ث هـ و ي

كلمن حطي حطي هوز ابجد
50 40 30 20 10 9 8 7 6 5 4 3 2 1

صض سش ذرز دذخ جحخ ابتث

Arabic letters can be arranged into a historical or graphical system.

The 'abjad' is a historical system where letters are sorted according to their numerical value. This method is still in use to list items such as in an outline or numbering pages in classical books.

The most modern and known method consists of arranging letters according to their graphical resemblance. Letters with the same basic shapes are grouped one after the other and distinguished with diacritical marks.

rsm

rasama...to draw

rasma..drawing

marsoum.......................................drawn

rassam ...painter

Words in Arabic are built according to a root system. Roots are words composed of a few letters that can be joined with suffixes or prefixes in order to signify relationships: ṭ–l–b could become 'ṭalib' (student), 'maṭloub' (wanted), 'ṭalaba' (ask), and 'maṭlab' (a demand).

the letters ال

Al-ta'rif (ال) or ال الـتـعـريـف is the Arabic definite article, its English equivalent is the word 'the.'

Solar letters

ت ث د ذ ر ز س ش ص ض ط ظ ل ن

Lunar letters

ء ب ج ح خ ع غ ف ق ك م و ي ه

The consonants in the Arabic alphabet are divided into solar and lunar letters. The two letter groups behave differently when preceded by the definite article ال pronounced 'al.' If ال is followed by a sun letter, the l or 'alif' is not pronounced and the following consonant carries a stress mark. For example, 'sun' (الـشـمـس), pronounced 'ashshams,' instead of 'alshams.' When the definite article is followed by a moon letter, 'al' is pronounced.

this
is
not
a V !

It is number 7 written in Arabic-Indic numerals

يُضبط النص اللاتيني
بواسطة المباعدة بين
الكلمات والمباعدة بين
الحروف وفي بعض الأحيان
بإستعمال الواصلة. أما
النص العربي فيُضبط من
خلال إطالة الوصل بين
الحروف. تُعرف هذه الإطالة
بالكشيدة وهي مستعملة
في خط اليد وفي الخط المطبعي.

Latin text is justified using word spacing, inter-character spacing and in some cases hyphenation. Arabic script is justified by horizontally elongating the connections between letters. This type of expansion in Arabic is called kashida. Kashida is used in both typography and handwritten texts.

*In Mirsaal Arabic unconnected text can be justified using word and letter spacing as in Latin typography.

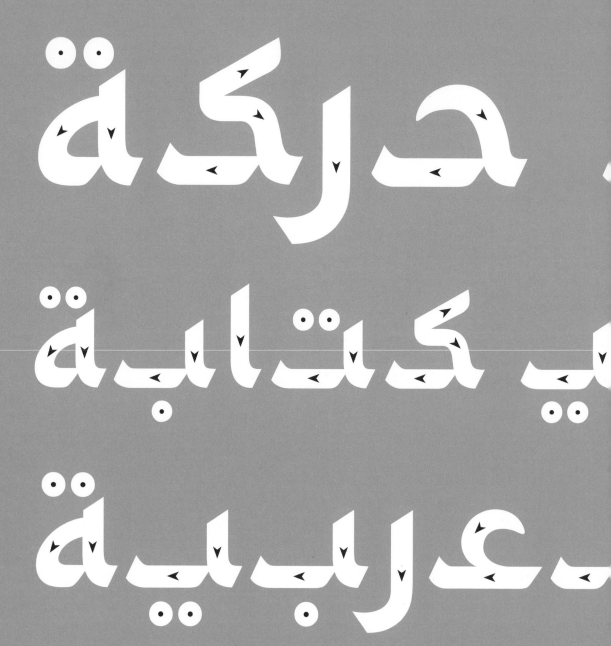

إتجاهت

المقلمة

الأحرف

The flow of writing in Arabic demands more pen movement than languages based on the Latin alphabet. In Arabic, most letters carry diacritical marks (including vocalization and stress marks) and not all letters are connected from both sides. Because of this, the movement of the pen can be stopped several times when writing one word.

the **Latin script** is characterized by

vertical movements

because of **the Upright** nature of the letters

whereas Arabic typography is based on a fixed horizontal baseline

يتميّز النص اللاتيني

بـــحـــركة عـــمـــوديـــة

بـسـب اشكـال حـروفــه المـعـموديـة

أما الــخط الـعـربـي

المطبعي فيعتمد على

أساس أفـقـي

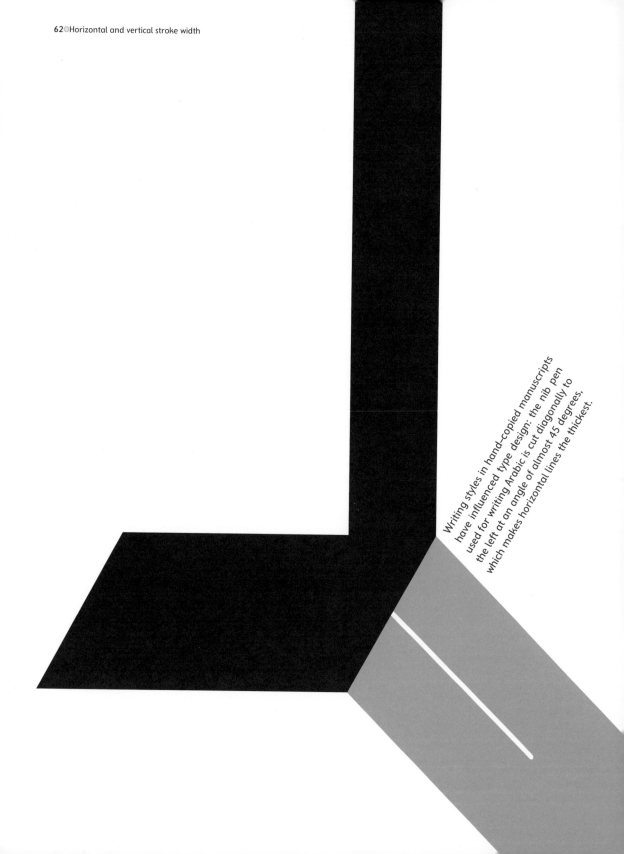

Writing styles in hand-copied manuscripts have influenced type design: the nib pen used for writing Arabic is cut diagonally to the left at an angle of almost 45 degrees, which makes horizontal lines the thickest.

The Latin calligraphic pen is cut diagonally to the right, which makes vertical strokes the thickest. It should be noted that pen angles could vary depending on the calligraphic style.

this
is
not
a flipped 3!

It is number 4 written in Arabic-Indic numerals

ارلماكد

ita

italics

lics الخط

الدخ

Italic Latin typefaces originated in 16th–century Italy as a result of copying Latin lettering found in hand–copied books. Italics are known for economizing layout space. Arabic italic fonts were created to match Latin italics visually. Today, many Arabic fonts have an italic version.

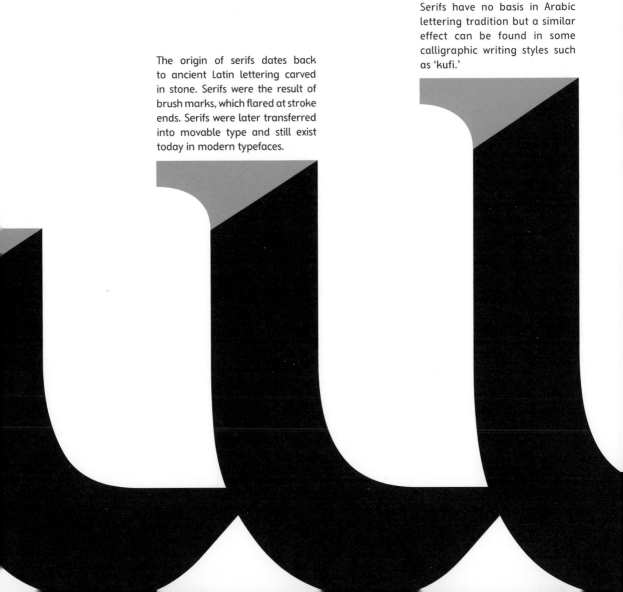

The origin of serifs dates back to ancient Latin lettering carved in stone. Serifs were the result of brush marks, which flared at stroke ends. Serifs were later transferred into movable type and still exist today in modern typefaces.

Serifs have no basis in Arabic lettering tradition but a similar effect can be found in some calligraphic writing styles such as 'kufi.'

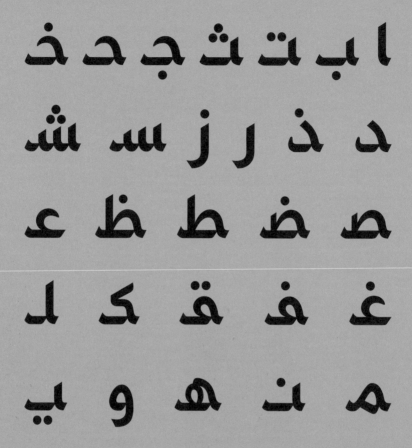

Uppercase and Lowercase are a Latin alphabet convention.
The Latin alphabet existed first in the majuscule form, where all letters share the same height (later called uppercase in reference to where the majuscule moveable metal letters were stored in printing presses). These letters were carved in stone and later turned into minuscule (lowercase) as a result of handwritten cursive scripts.

In Arabic, uppercase and lowercase do not exist. The first letter in the first word of an Arabic sentence is written exactly the same as it would be when placed in the middle of a sentence – the same principle applies to proper names.

Aa Bb Cc Dd Ee
Ff Gg Hh Ii Jj Kk
Ll Mm Nn Oo Pp
Qq Rr Ss Tt Uu
Vv Ww Xx Yy Zz

"How is Mary looking?" said Sir Walter, in the height of his good humour. "The last time I saw her, she had a red nose, but I hope that may not happen every day."
"Oh! no, that must have been quite accidental. In general she has been in very good health, and very good looks since Michaelmas."
... Anne was considering whether she should venture to suggest a gown, or a cap, would not be liable to any such misuse, when a knock at the door suspended every thing.
"A knock at the door! and so late! It was ten o'clock. Could it be Mr. Elliot?" Jane Austen

The old Latin script was first written without any punctuation. The period was first introduced to show how a text should be read aloud. Later non-alphabetical marks defined moments of rest and emphasis. With the invention of printing, punctuation started being used for denoting the structure of a text.

Many scripts, including Arabic, adopted these marks and slightly adjusted them. This explains why most punctuation marks are roughly the same as those used in the Latin script; Arabic punctuation marks are either rotated or flipped.

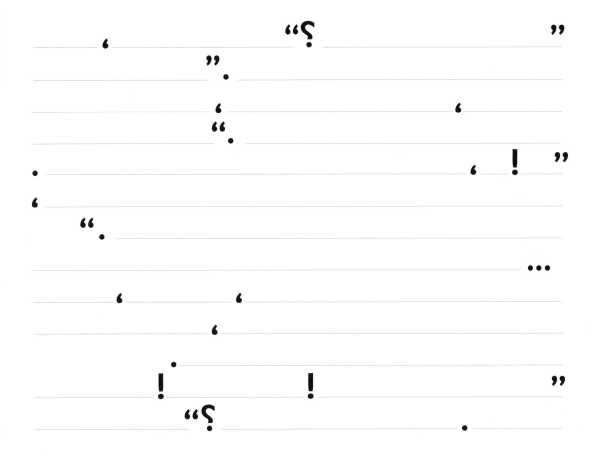

In Arabic, most of the punctuation marks are a reflection or a rotation of those in Latin.

bablo bicasso
antonio fifaldi
ludwigh fan beethofen

The sounds (vee, pee, and 'g' as in 'gulf') do not have an Arabic equivalent. If a proper noun from a foreign language containing any of these sounds needs to be transliterated into Arabic the corresponding letters are substituted by the closest letter existing in the Arabic alphabet. In some cases, the letters representing these sounds are borrowed from Persian.

letter	letter name	letter transliteration
ا	alif	ʼ/ā
ب	bāʼ	b
ت	tāʼ	t
ث	thāʼ	th
ج	jīm	j
ح	ḥāʼ	ḥ
خ	khāʼ	kh
د	dāl	d
ذ	dhāl	dh
ر	rāʼ	r
ز	zā	z
س	sīn	s
ش	shīn	sh
ص	ṣād	ṣ
ض	ḍād	ḍ
ط	ṭā	ṭ
ظ	ẓā	ẓ
ع	ayn	ʻ
غ	ghayn	gh
ف	fāʼ	f
ق	qāf	q
ك	kāf	k
ل	lām	l
م	mīm	m
ن	nūn	n
ه	hāʼ	h
و	wāw	w/ū
ي	yāʼ	y/ī
ء	hamza	ʼ

Ever wonder
what it sounds like?

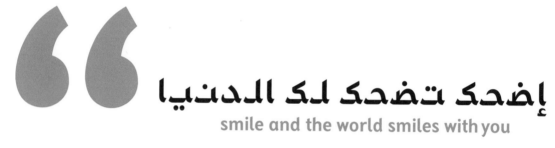

" إضحك تضحك لك الدنيا

smile and the world smiles with you

iḍḥak taḍḥak laka
addunyā **"**

" من فتح مدرسة أغلق سجناً "

he who opens a school door, closes a prison

man fataḥa madrasa aghlaqa sijnan "

" المحاجة أم الاختراع "

necessity is the mother of invention

alḥāja 'um alikhtirā' "

Arabic is known as the language of the ض (pronounced as a heavy 'd' followed by an 'h' as if exhaling) because it is believed to be the only language containing that specific letter sound.

دعيت اللغة العربية لغة الـ"ض" كونها اللغة الوحيدة في العالم التي تحتوي على هذا الحرف.

ḍād

Has it occured to you that you are familiar with many Arabic words?

Alcohol
الغول alghul : evil spirit

Carafe
غرافة gharāfa : to draw water

Cipher
صفر sifr : emptiness or nothingness

Cotton
قطن quṭun

Crimson
قرمزي qarmazī

Elixir
الإكسير aliksīr

Fakir
فقير faqīr : poor man

Giraffe
زرافة zarāfa

Jasmine
ياسمين yasmīn

Magazine
مخازن makhāzin storehouses

Mattress
مطرح matraḥ the place where something is thrown

Monsoon
موسم mawsam season

Risk
رزق riziq fortune

Spinach
سبانخ sabāniḵh

Sugar
سكّر sukkar

Tariff
تعريفة taʿrīfa rate

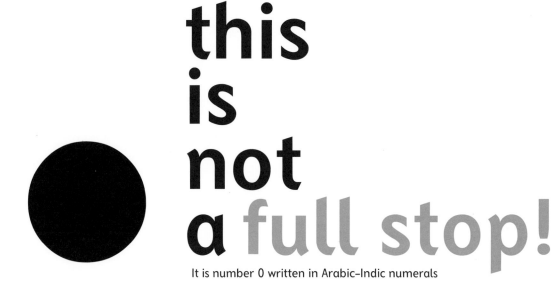

this
is
not
a full stop!

It is number 0 written in Arabic–Indic numerals

The zero or the 'sifr' (cipher) indicates nothingness in order to make sure other digits are positioned in the right place. To distinguish the zero from the full stop, the full stop is placed on the baseline and the zero is represented as a centered dot. In conventional fonts the zero is diamond shaped (•), in reference to the short movement of the calligraphic pen.

About Mirsaal حول مرسال

Mirsaal Arabic is a simplified typeface that carries the characteristics of a sans-serif humanist Latin alphabet typeface that respects the essence of the handwritten form.

The Arabic letterforms were inspired by the 'naskh' style; the most legible and simplified cursive Arabic writing. Because of the considerable divergence between these two scripts, it was crucial to develop a typeface that would help convey the cultural essence and conventions of Arabic script.

While Arabic is always written in cursive, Mirsaal removes its joined nature in order to attain a harmonious coexistence between both scripts when used together in the same layout.

While Arabic is always written as a cursive script, the Arabic Mirsaal font can be connected and disconnected. Arabic Mirsaal and Latin Mirsaal have the same block letter print form and look better together because of this characteristic.

Arabic and Latin Mirsaal feature the same stroke width and thick-to-thin variations and open counters in order to achieve balance and harmony when used in conjunction with one another. For Arabic letters (in contrast to traditional fonts) open counters are standardized. Misraal Arabic and Latin were created in unison and slight changes were applied to the Arabic script to accommodate the purpose.

The one-shape-per-letter system should help facilitate the task of learning Arabic. By adopting Mirsaal, the student will find it easier to learn the language because it relies on fewer shapes than originally imposed in traditional Arabic. Mirsaal can streamline design in advertising copy that makes use of English and Arabic simultaneously.

Mirsaal regular

ٱأإآآبتثجحخدذرز

سشصضطظعغفق

كلمنهويةلالألإلآ

٠١٢٣٤٥٦٧٨٩ءؤئ ىـكـ

[]

*""''(())...؟!؛،.:؛،{}()

¾ ½ ¼ ‰ % × + ÷ = ± <>

ABCDEFGHIJKLMNO

PQRSTUVWXYZabc

defghijklmnopqrst

uvwxyz0123456789

✿ Mirsaal regular

مرسال 9/12pt

الخط المطبعي هو كالموسيقى يمتاز بجمال
خاص لتأدياتي المرافقة والتعبير إذ يمكن
إستعماله للتعبير عن حالة نفسية على غرار
سائر الفنون والحرف اليدوية. ولكن على مثالها
يستعمل الخط المطبعي أيضاً بصورة آلية،
وفي هذه الحالة فإن كل إمكاناته التعبيرية
لا تتحقق. وفي حال إستخدامه حسب القواعد
والمواصفات يصبح باهتاً ويفقد من حيويته.
والحرف المطبعي يبدو لأول وهلة جامداً ولكن
مثل الوسائل الأخرى فهو يبدو طبيعاً وقادراً على
خدمة روح الحرفي النابضة بالحياة."

Mirsaal 9/12pt

"Type is like music in having its own beauty, and
in being beautiful as an accompaniment and
interpretation; and typography can be used to
express a state of the soul, like the other arts
and crafts. But like them it is too often used
mechanically, and so the full expressiveness of
this medium is unrealized. If it is used according
to a rule or recipe, it becomes dull and loses
vividness. Type appears at first to be a rigid
medium; but like other rigid media, it is plastic
to the living spirit of a craftsman."

مرسال 10/13pt

الخط المطبعي هو كالموسيقى يمتاز
بجمال خاص لتأدياتي المرافقة والتعبير إذ
يمكن إستعماله للتعبير عن حالة نفسية
على غرار سائر الفنون والحرف اليدوية.
ولكن على مثالها يستعمل الخط المطبعي
أيضاً بصورة آلية، وفي هذه الحالة فإن
كل إمكاناته التعبيرية لا تتحقق. وفي
حال إستخدامه حسب القواعد والمواصفات
يصبح باهتاً ويفقد من حيويته. والحرف
المطبعي يبدو لأول وهلة جامداً ولكن مثل

Mirsaal 10/13pt

"Type is like music in having its own beauty,
and in being beautiful as an accompaniment
and interpretation; and typography can
be used to express a state of the soul, like
the other arts and crafts. But like them it is
too often used mechanically, and so the full
expressiveness of this medium is unrealized.
If it is used according to a rule or recipe,
it becomes dull and loses vividness. Type
appears at first to be a rigid medium; but

مرسال 12/15pt

"الخط المطبعي هو كالموسيقى
يمتاز بجمال خاص لتأدياتي المرافقة
والتعبير إذ يمكن إستعماله
للتعبير عن حالة نفسية على غرار
سائر الفنون والحرف اليدوية. ولكن
على مثالها يستعمل الخط المطبعي
أيضاً بصورة آلية، وفي هذه الحالة فإن
كل إمكاناته التعبيرية لا تتحقق.

Mirsaal 12/15pt

"Type is like music in having its own
beauty, and in being beautiful as an
accompaniment and interpretation;
and typography can be used to express
a state of the soul, like the other arts
and crafts. But like them it is too
often used mechanically, and so the
full expressiveness of this medium is

. J.H. Mason

Mirsaal bold

ارأإإآاأبتثتـجـجحخدخدذرز

سشصضطظعـغفـقـ

كـلـمـنـهـويـةلالألألآلآ

٠١٢٣٤٥٦٧٨٩ءؤئبى

[ّ ُ َ ِ ً ٍ ٌ]

*""''«()»...؟!،؛،.{}()

¾ ½ ¼ ‰ % × + ÷ = ± <>

ABCDEFGHIJKLMNO

PQRSTUVWXYZabc

defghijklmnopqrst

uvwxyz0123456789

❀ Mirsaal bold

مرسال 9/12pt

"الخط المطبعي هو كالموسيقى يمتاز بجمال خاص لناحيتي المرافقة والتعبير إذ يمكن إستعماله للتعبير عن حالة نفسية على غرار سائر الفنون والحرف اليدوية. ولكن على مثالها يستعمل الخط المطبعي أيضاً بصورة آلية، وفي هذه الحالة فإن كل إمكاناته التعبيرية لا تتحقق. وفي حال إستخدامه حسب القواعد والمواصفات يصبح باهتاً ويفقد من حيويته. والحرف المطبعي يبدو لأول وهلة جامداً ولكن مثل الوسائل الأخرى فهو يبدو طيعاً وقادراً على خدمة روح الحرفي النابضة بالحياة."

Mirsaal 9/12pt

"Type is like music in having its own beauty, and in being beautiful as an accompaniment and interpretation; and typography can be used to express a state of the soul, like the other arts and crafts. But like them it is too often used mechanically, and so the full expressiveness of this medium is unrealized. If it is used according to a rule or recipe, it becomes dull and loses vividness. Type appears at first to be a rigid medium; but like other rigid media, it is plastic to the living spirit of a craftsman."

مرسال 10/13pt

"الخط المطبعي هو كالموسيقى يمتاز بجمال خاص لناحيتي المرافقة والتعبير إذ يمكن إستعماله للتعبير عن حالة نفسية على غرار سائر الفنون والحرف اليدوية. ولكن على مثالها يستعمل الخط المطبعي أيضاً بصورة آلية، وفي هذه الحالة فإن كل إمكاناته التعبيرية لا تتحقق. وفي حال إستخدامه حسب القواعد والمواصفات يصبح باهتاً ويفقد من حيويته. والحرف المطبعي يبدو لأول وهلة جامداً ولكن مثل الوسائل

Mirsaal 10/13pt

"Type is like music in having its own beauty, and in being beautiful as an accompaniment and interpretation; and typography can be used to express a state of the soul, like the other arts and crafts. But like them it is too often used mechanically, and so the full expressiveness of this medium is unrealized. If it is used according to a rule or recipe, it becomes dull and loses vividness. Type appears at first to be a rigid medium; but

مرسال 12/15pt

"الخط المطبعي هو كالموسيقى يمتاز بجمال خاص لناحيتي المرافقة والتعبير إذ يمكن إستعماله للتعبير عن حالة نفسية على غرار سائر الفنون والحرف اليدوية. ولكن على مثالها يستعمل الخط المطبعي أيضاً بصورة آلية، وفي هذه الحالة فإن كل إمكاناته التعبيرية

Mirsaal 12/15pt

"Type is like music in having its own beauty, and in being beautiful as an accompaniment and interpretation; and typography can be used to express a state of the soul, like the other arts and crafts. But like them it is too often used mechanically, and so the full expressiveness of this medium

... J.H. Mason

Comparison between Mirsaal Latin and Mirsaal Arabic letterforms and proportions

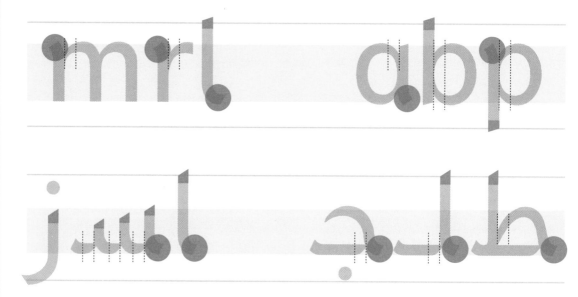

Mirsaal Arabic detached form

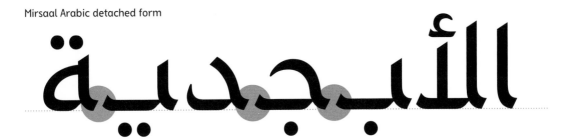

Mirsaal Arabic connected form

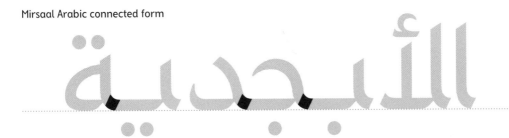

Mirsaal Arabic connected sample text

"الخط المطبعي هو كالموسيقى يمتاز بجمال خاص لناحيتي المرافقة
والتعبير إذ يمكن إستعماله للتعبير عن حالة نفسية على غرار سائر
الفنون والحرف اليدوية. ولكن على مثالها يستعمل الخط المطبعي
أيضاً بصورة آلية. وفي هذه الحالة فإن كل إمكاناته التعبيرية
لا تتحقق. وفي حال إستخدامه حسب القواعد والمواصفات يصبح
باهتاً ويفقد من حيويته. والحرف المطبعي يبدو للأول وهلة جامداً
ولكن مثل الوسائل الأخرى فهو يبدو طيعاً وقادراً على خدمة روح
الحرفي النابضة بالحياة."

Letterforms in connected Arabic

medial joined/final joined : isolated/medial unjoined/final unjoined

Letterform in Mirsaal

final position : medial position : initial position

Letterforms in connected Arabic

final form : medial form : initial form : isolated

 : : :

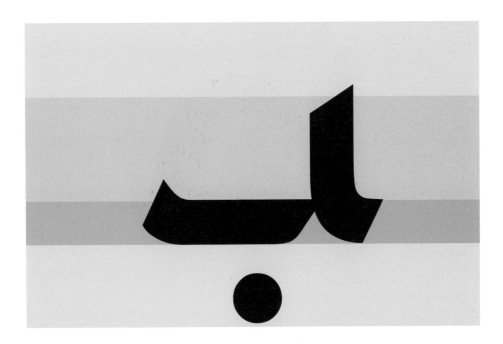

 : :

Letterform in Mirsaal

final position : medial position : initial position

 :

Letterforms in connected Arabic

final form	medial form	initial form	isolated
جـ	ـجـ	ـج	ج

Letterform in Mirsaal

final position	medial position	initial position
مالـج	مجال	جمال

Letterforms in connected Arabic

medial joined/final joined : isolated/medial unjoined/final unjoined

د د : د

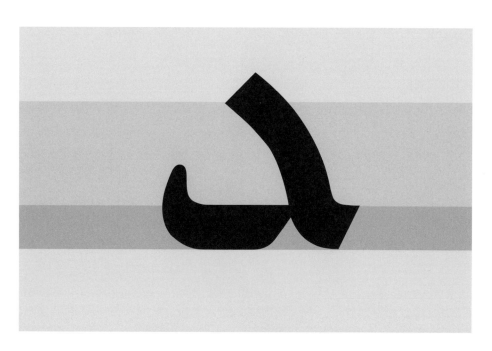

د ذ : د ذ

Letterform in Mirsaal

final position : medial position : initial position

برد درب : بدر : درب

Letterforms in connected Arabic

medial joined/final joined ⠇ isolated/medial unjoined/final unjoined

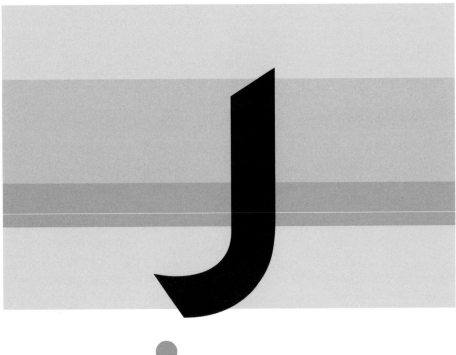

Letterform in Mirsaal

final position ⠇ medial position ⠇ initial position

سـفـر ⠇ فـرسـ ⠇ رفـسـ

Letterforms in connected Arabic

final form	medial form	initial form	isolated
ﺲ	ﺴ	ﺳ	س

Letterform in Mirsaal

final position	medial position	initial position

Letterforms in connected Arabic

final form : medial form : initial form : isolated

ﺺ ﺼ ﺻ ص

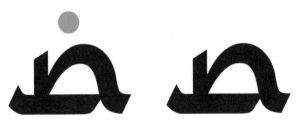

Letterform in Mirsaal

final position : medial position : initial position

ﺺﺑﺮ ﺑﺼﺮ ﺻﺒﺮ

Letterforms in connected Arabic

final form	medial form	initial form	isolated
ط	ط	ط	ط

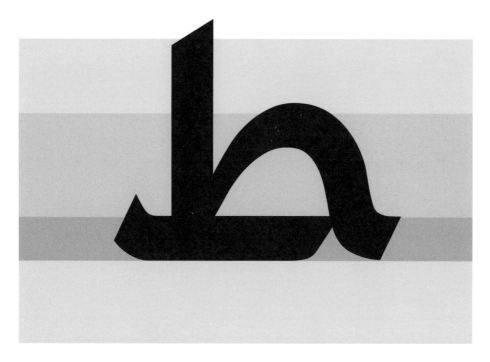

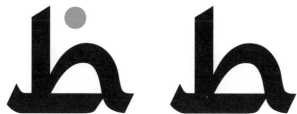

Letterform in Mirsaal

final position	medial position	initial position
رفط	فطر	طرف

Letterforms in connected Arabic

final form	medial form	initial form	isolated

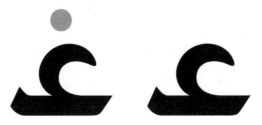

Letterform in Mirsaal

final position	medial position	initial position

 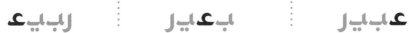

Letterforms in connected Arabic

final form	medial form	initial form	isolated

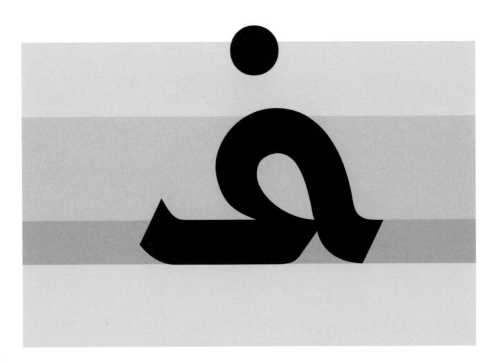

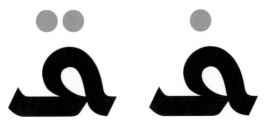

Letterform in Mirsaal

final position	medial position	initial position

Letterforms in connected Arabic

final form	medial form	initial form	isolated
ك	ک	ک	ك

Letterform in Mirsaal

final position	medial position	initial position
ربک	بکر	کرب

Letterforms in connected Arabic

final form : medial form : initial form : isolated

لـ ـلـ لـ ل

Letterform in Mirsaal

final position : medial position : initial position

لعـ : ـلـعـ : ـعـل

Letterforms in connected Arabic

final form		medial form		initial form		isolated
	:		:		:	

Letterform in Mirsaal

final position		medial position		initial position
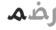	:	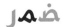	:	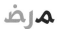

Letterforms in connected Arabic

final form	medial form	initial form	isolated
ﻦ	ﻨ	ﻧ	ن

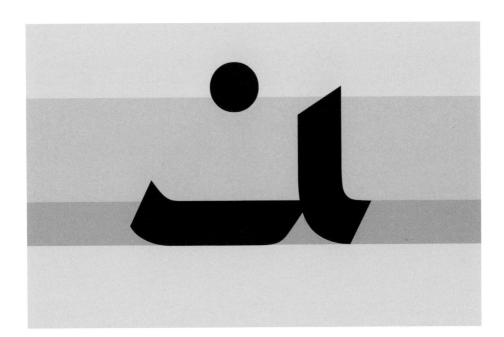

Letterform in Mirsaal

final position	medial position	initial position

Letterforms in connected Arabic

final form : medial form : initial form : isolated

Letterform in Mirsaal

final position : medial position : initial position

Letterforms in connected Arabic

medial joined/final joined ┊ isolated/medial unjoined/final unjoined

و ┊ و

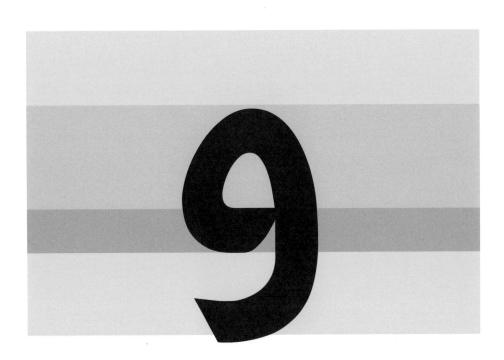

Letterform in Mirsaal

final position ┊ medial position ┊ initial position

علو ┊ لوع ┊ ولع

Letterforms in connected Arabic

final form	:	medial form	:	initial form	:	isolated
ي		ـيـ		يـ		ي

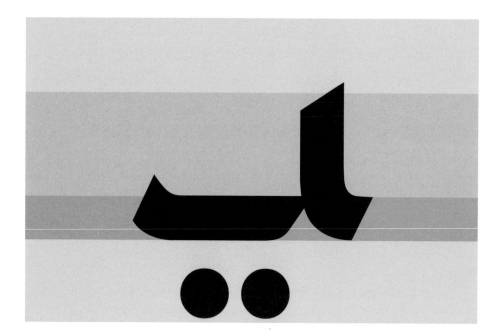

Letterform in Mirsaal

final position	:	medial position	:	initial position

Lettering and Calligraphy

Ahmad, Syed Barakat. Introduction to Qur'anic Script. London: Curzon, 1985.

Blair, Sheila. Islamic Calligraphy. United Kingdom: Edinburgh University Press, 2006.

Brown, Michelle P. The Historical Source Book for Scribes. London: British Library, 1999.

Drogin, Marc. Medieval Calligraphy. London: Allanheld & Schram, 1980.

Fraser, Marcus and Will Kwiatkowksi. Ink and Gold: Islamic Calligraphy. London: Sam Fogg, 2006.

Gaur, Albertine. A History of Calligraphy. London: British Library, 1992.

Jaafar, Mustafa. Arabic Calligraphy. London: British Museum, 2002.

Khatibi, Abdelkebir and Mohammed Sijelmassi. The Splendour of Islamic Calligraphy. New York: Thames & Hudson, 1996.

Schimmel, Annemarie. Calligraphy and Islamic Culture. London: Tauris, 1990.

Woodcock, John. A Book of Formal Scripts. London: A & C Black, 1991.

Latin Typography

Baines, Phil and Andrew Haslam. Type and Typography. London: Laurence King, 2002.

Bringhurst, Robert. The Elements of Typographic Style. Washington: Hartley and Marks, 1992.

Dowding, Geoffrey. An Introduction to the History of Printing Types. London: British Library and Oak Knoll Press, 1998.

Glaister, Geoffrey Ashall. Glossary of the Book. London: Allan and Unwin, 1960.

Lupton, Ellen. Thinking With Type: A Critical Guide for Designers, Writers, Editors, & Students. New York: Princeton Architectural Press, 2004.

McLean, Ruari. The Thames and Hudson Manual of Typography. London: Thames & Hudson, 1980.

Arabic Typography

Boutros, Mourad. Arabic for Designers. New York: Mark Batty, 2005.

Boutros, Mourad. Talking About Arabic. New York: Mark Batty, 2009.

Hamm, Roberto. Pour une Typographie Arabe : Contribution Technique la Démocratisation de la Culture Arabe. Paris: Sindbad, 1975.

Hourani, Cecil. "The Arabic Typographical Revolution: The Work of Nasri Khattar." (1982).

Khattar, Nasri. "Literacy for the Millions." International House Quarterly, Summer Issue (1952).

Kortbaoui, John. "Arabic Typography: A Brief History and Attempts to Reform it in Parallel With Latin typography." Typographic: Primal Typography, no. 60 (2004).

Milo, Thomas. "Arabic Amphibious Characters; Phonetics, Phonology, Orthography, Calligraphy and Typography." 33rd Unicode Conference (2009).

Milo, Thomas. "Arabic Script Tutorial." Deco Type– 29th Internationalization and Unicode Conference (2006).

Smitshuijzen AbiFares, Huda. Arabic Typography: A Comprehensive Sourcebook. London: Saqi, 2001.

Language

Austen, Jane. Persuasion. New York: Penguin Books, 2006.

Bateson, Marie–Catherine. Arabic Language Handbook. Washington: Georgetown University Press, 2003.

Cowan, David. Modern Literary Arabic. Cambridge: Cambridge University Press, 1958.

Crystal, David. The Cambridge Encyclopedia of Language. United Sates of America: Cambridge University Press, 1992.

Hendrickson, Robert. The Facts on File Encyclopedia of Word and Phrase Origins. New York: Facts on File, 2004.

Milo, Thomas. "Ali–Baba and the 4.0 Unicode Characters; New Input and Output Concepts Under Unicode." TU Gboat 24 (2003).

Nicholas, Awde and Putros Samano. The Arabic Alphabet: How to Read and Write it. London: Saqi Books, 1986.

Parkes, M.B. Pause and Effect: An Introduction to the History of Punctuation in the West. California: Scolar Press, 1993.

History of Writing

Haley, Allan. Alphabet: The History, Evolution and Design of Letters we use Today. London: Thames & Hudson, 1995.

Robinson, Andrew. The Story of Writing. London: Thames & Hudson, 2003.

Sacks, David. The Alphabet. London: Hutchinson, 2003.

UNESCO. "The Art of Writing; An Exhibition in Fifty Panels." UNESCO, http://unesdoc.unesco.org/images/0005056424/000564/eb.pdf

Numbering Systems

Ifrah, Georges. Histoire Universelle des Chiffres. Paris: Seghers, 1981.

Design Writing

Lupton, Ellen & J. Abbott Miller. Design Writing Research: Writing on Graphic Design. New York: Phaidon, 1999.

Sailing

A Wiley Brand

Sailing

3rd Edition

**JJ Fetter and Peter Isler
with Marly Isler**

A Wiley Brand

Sailing For Dummies®, 3rd Edition

Published by: **John Wiley & Sons, Inc.,** 111 River Street, Hoboken, NJ 07030-5774, www.wiley.com

Copyright © 2022 by John Wiley & Sons, Inc., Hoboken, New Jersey

Published simultaneously in Canada

For general information on our other products and services, please contact our Customer Care Department within the U.S. at 877-762-2974, outside the U.S. at 317-572-3993, or fax 317-572-4002. For technical support, please visit https://hub.wiley.com/community/support/dummies.

Wiley publishes in a variety of print and electronic formats and by print-on-demand. Some material included with standard print versions of this book may not be included in e-books or in print-on-demand. If this book refers to media such as a CD or DVD that is not included in the version you purchased, you may download this material at http://booksupport.wiley.com. For more information about Wiley products, visit www.wiley.com.

Library of Congress Control Number: 2022940419

ISBN 978-1-119-86723-4 (pbk); ISBN 978-1-119-86724-1 (ebk); ISBN 978-1-119-86725-8 (ebk)

SKY10035008_062822

Contents at a Glance

Table of Contents

Introduction

There is nothing — absolutely nothing — half so much worth doing as simply messing about in boats.

<div align="right">

—*WATER RAT TO MOLE, THE WIND IN THE WILLOWS,*
BY KENNETH GRAHAME

</div>

What gives sailing such enchanting prospects? Water Rat certainly had a piece of the puzzle. Messing about in a boat — any kind of boat — is great fun. You escape the cares and stresses of everyday life, conveyed on a craft powered solely by the forces of nature. The spell that the wind casts on the sails of a boat is bewitching to behold.

Maybe the best part of sailing is the part that your imagination can latch onto, conveying your mind to places you've never been, promising experiences yet untold. And no matter how experienced you become or how much water passes beneath your keel, sailing still has more to offer. The sport is so vast that no one can experience all of sailing's facets in a single lifetime.

But enough generalizing. After all, you wouldn't have picked up this book if you weren't already at least intrigued by the allure of sailing.

About This Book

In this book, you can find all the information you need to go sailing. This book is a textbook, user manual, and reference book all in one. We start with basic sailing skills and move on to cover more advanced topics for when you widen your horizons to activities such as chartering a boat and going cruising. You get to practice tying knots, and you find out about sailing such diverse crafts as a kiteboard and a catamaran. You'll learn how to forecast the weather, as well as how to have a fun and safe day at anchor. You even discover the basics of sailboat racing. We cover all you need to know to be safe on the water, and we make the whole process easy and fun!

This third edition of *Sailing For Dummies* is full of new and revised information. In addition to new photos, we've

>> Revised the text on safety equipment and navigation with the most current information

>> Updated the sailboat-racing chapter and our advice on what to wear and bring

>> Added the best apps and websites for sailing, navigation, and safety

>> Invited our daughter, Marly, to revise and expand our chapter on windsurfing to include kiteboarding and foiling

Have you ever listened in on the conversation of two sailors? Sailing has so many specific words that sailors can sound like they're speaking a foreign language. But don't let the jargon turn you off. The language of sailing has an old and rich tradition, and as you become more comfortable in a sailboat, you gradually pick up more and more of the language and become part of the sailing tradition yourself.

In this book, we try to avoid using sailing jargon, but we can't get around it completely, because some of the terms are very important for safety. When the skipper plans a maneuver that requires a coordinated crew effort, for example, using and understanding the exact sailing term allows everyone on the boat to know what's happening and what to do.

We use the following conventions to help you understand everything that we're discussing and to stay consistent:

>> We *italicize* boat names and new terms, and follow them with easy-to-understand definitions. We also list most of the italicized terms in the glossary so that you can brush up on sailing terminology.

>> We **boldface** important keywords in bulleted lists as well as the action parts of numbered lists.

Finally, in this book we simply refer to *boats* or *sailboats*. Sometimes, we further differentiate between big sailboats with keels (*keelboats*) and small sailboats with centerboards (*dinghies*) as necessary for the subject we're covering. (In the United States, a *yacht* is the snobby cousin of the boat, but in New Zealand and much of the current and former British Empire, the word *yacht* has no elitist connotations.)

Foolish Assumptions

The most foolish assumption we made when we wrote the first edition of this book was that only our parents and a few close friends would ever read it. We've been overwhelmed by the positive responses to the first two editions, and we hope that you enjoy all the new information we've crammed into this book. We assume one or more of the following things about you, our reader:

>> You've been given this book as a gift by a friend who wants to take you sailing.

>> You get dragged out on the water by your sailing-loving family, and you don't really know what to do.

>> You've always been intrigued by the sea.

>> You may have had a bad experience on the water, but now you want to give sailing another try.

>> Your child has been bitten by the sailboat-racing bug, and you want to figure out what you're watching.

>> You love the water and enjoy powerboats, but a sailboat seems to be better for the environment (and cheaper).

>> You discovered the basics of sailing at summer camp and haven't sailed since then, but now you want to charter a boat in the Caribbean.

>> You already enjoy sailing and want a good, complete reference book and ideas for exploring some new directions in the sport.

We wrote this book to lure you into the sport that we love — no matter how you came to turn that first page.

Icons Used in This Book

You may notice icons, or cute little pictures, in the margins of this book. Those icons do more than just break up the white space; they also tell you something about that particular paragraph.

WARNING

This symbol helps you avoid common mistakes while you're starting and alerts you to potential dangers. As a sailor, you need to have a healthy respect for the power of the wind and the sea.

This icon points out information that we don't want you to forget. Store it in your brain for quick recall at a later time.

In sailing, because you're letting the wind do the work, the easy way is the right way. These tips can help you find the easy way.

This icon highlights more detailed information that isn't critical but that can enhance your knowledge and make you a better sailor.

Beyond the Book

In addition to the hundreds of pages of information in this book, you can access more tips, advice, and reference material online. Just go to www.dummies.com and type "Sailing For Dummies Cheat Sheet" in the search box.

Where to Go from Here

Where you start is up to you. If you're brand-new to the world of sailing, just turn the page and start with Chapter 1. If you've been around boats before, browse the table of contents and pick a chapter that interests you.

But do start somewhere. The faster you start, the faster we can share our love of sailing with you. While cruising, we've explored some of the most remote and beautiful parts of the world. While racing, we've had the chance to challenge ourselves in international competitions and make friends around the globe. Who knows? Maybe on a future voyage, we'll even get a chance to meet you.

1

Before You Get Your Feet Wet

Get a formal introduction to a sailboat.

Discover where you can take sailing lessons.

Find out what you should wear and what kind of equipment you need.

Study what you need to know before you leave the dock.